TANKS AND HOW TO DRAW THEM

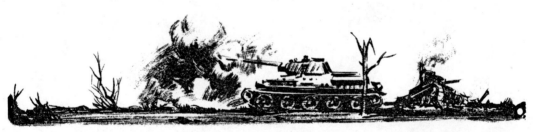

Russian cruiser tank.

TANKS
AND HOW TO DRAW THEM

BY

Cuneo

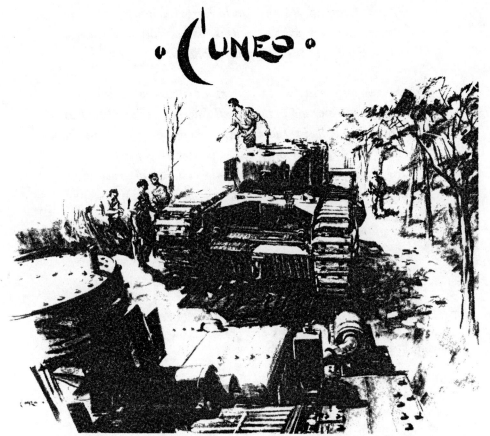

Early Mark II Churchill on test.

COACHWHIP PUBLICATIONS
Landisville, Pennsylvania

First published January 1943
New and revised edition June 1945

ACKNOWLEDGMENTS

I would like to thank the publishers of the "Illustrated London News," Imperial Chemical Industries Ltd., The Oxford University Press, and George Newnes Ltd., for allowing me to include in this book several drawings commissioned for their various publications.

I am also grateful to officers and men of the Royal Tank Regiment and of the Royal Engineers whose help has been invaluable in the compilation of this book, and in particular to one, George, whose painstaking consideration in posing his "Valentine" up banks of incredible steepness afforded me such fine opportunities for action studies.

Tanks and How to Draw Them, by Terence T. Cuneo
Original Publication in New York and London, 1945
Reprint, © 2010 Coachwhip Publications

ISBN 1-61646-021-0
ISBN-13 978-1-61646-021-1

Coachwhipbooks.com

CONTENTS

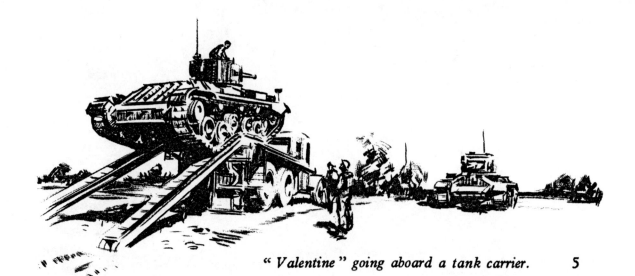

" Valentine " going aboard a tank carrier. 5

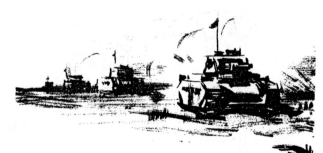

"Waltzing Matilda's" in the desert.

INTRODUCTION

As the title of this book suggests, I want in the following pages, to try to show you methods of drawing tanks, and how your drawings can be made to look real and full of action.

My object is not to teach you to draw perfect and technically accurate prototypes of the modern tank, there are many who could far excel me at that, but rather to encourage the vividness, realism and sense of environment, that can make all the difference between dull academic drawings and lively vigorous ones. I want your tanks to look as if they are really doing a job of work ; as if their decks and running boards are used to the abrazions of hob-nailed boots, and as though old mud still clings and oozes from the chutes, and all sorts of articles, chains, hawsers, camouflage nets, shovels and tarpaulins, might well be draped or lashed to their iron flanks.

The tank is anything but a delicate or refined " engine of war ". Its coach work would break the heart of the average car owner, and the roar of its engines and rattle of its caterpillar tracks can only be

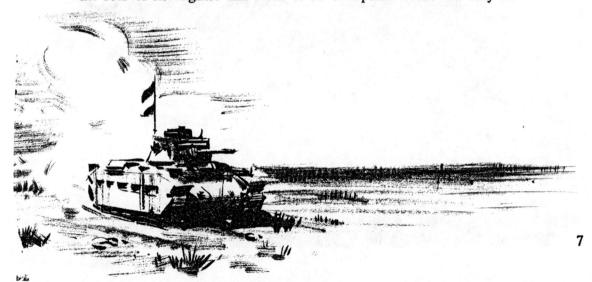

described as shattering. To my mind it is a lumbering rather awe-inspiring mass of metal, having three distinct qualities—its weight, its strength, and its grimly business-like appearance.

Whenever you draw a tank, remember these three characteristics. Remember too, that a tank is constructed of steel and its weight is an all-important factor. Therefore it must be made to look heavy, and suggest ponderous strength in the drawings you make.

Let's see if I can show you how you can get these effects.

TERENCE T. CUNEO.

A mark III Valentine goes on the ' slab ' for repairs.

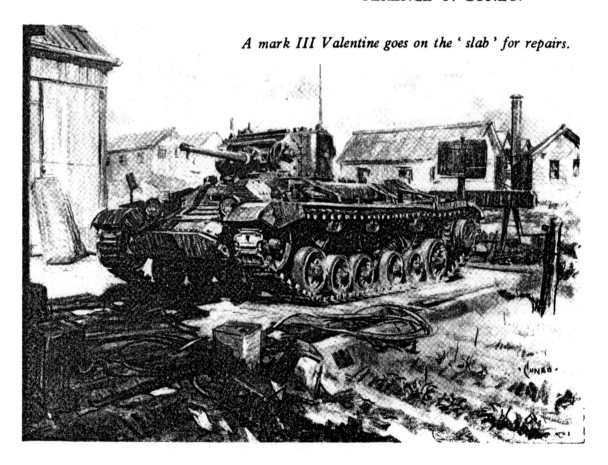

DIRECTNESS AND DECISION

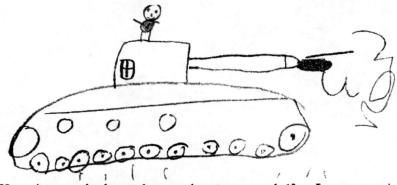

Here is a tank drawn by my daughter, aged 6¾. It was put down in four minutes, and from memory. Although a somewhat strange vehicle, and having a Commander more like a good natured insect than a man, the drawing has, in my opinion two distinct merits— directness and observation.

I said to Linda, "Draw me a Tank," and she took up her pencil (with unnecessary firmness) and drew me a Tank. Just like that. There were no feathery guiding lines and no hesitation. The firing gun is the predominant factor, and it cost the pencil its point. But at least the drawing shows decision in application, and to my mind is therefore worth a hundred of the more accurate, more conscientious fluffy type of drawings.

Russian K.V.2 with
a 152 mm. gun.

Make one firm line and not a lot of indeterminate ones

Here are two impressions of the same tank. (the German PANTHER)
The left hand sketch is by far the more accurate of the two. But it is dull Boring. It lacks colour and it lacks — Guts!

IN THE FORMER, THE ARTIST HAS ACHIEVED ACCURACY BECAUSE HE WAS AFRAID TO MAKE MISTAKES.

IN THE LATTER HE HAS ACHIEVED CHARACTER AND DECISION BECAUSE HE HAD THE COURAGE TO MAKE MISTAKES!

Again, the child's observation is illustrated by her instinctive handling of the tank's components.

Admittedly, those wheels could never rotate. But she has noticed that tanks have big wheels fore and aft; and although unaware of their purpose, she has remembered the three return rollers above. The turret too, is none too bad a shape, and although men should not perch on its roof plate, the figure marks the correct position for the Commander's hatch.

To sum up. If you've got something to say, stick it down *boldly*, and don't be afraid to spoil paper and make mistakes. A good mistake is worth an hour of over-cautious indecision.

BUILDING UP

Anything that is to be built, whether it be a cathedral or a rocking-chair, must be soundly constructed. If construction is faulty, then the finished article cannot hope to be successful. This rule holds good for drawing no less than for any other form of preliminary building.

There is little doubt that the finest method of drawing anything is to work direct from life. Unfortunately many of us will not get opportunities for sketching real tanks and, therefore I am afraid, we must fall back on the next best thing, photographs.

Now I want to make a point clear before we start. I am not in favour of copying photographs. By all means work from, and use photographs but do not religiously copy what you see. You will learn little and the results will be dull, and unimaginative. Having got proportions and essential shapes from the photo, try to break away and get some of your own personality into the drawing.

Before we go into the subject of "building-up" in greater detail, I want you to look at this sketch of a *Churchill IV*.

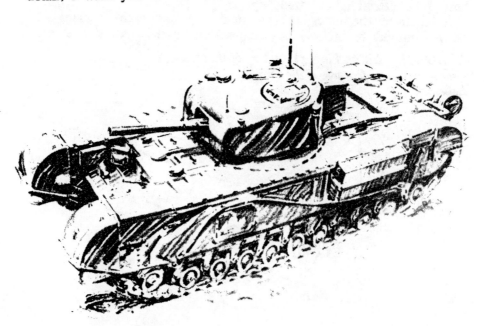

STAGE I. This is the shape of the tank's hull brought to its simplest possible form.

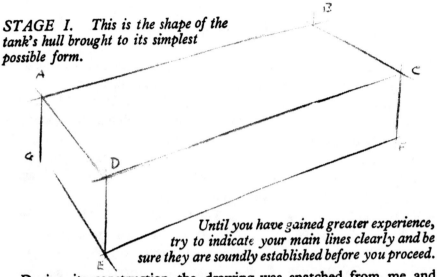

Until you have gained greater experience, try to indicate your main lines clearly and be sure they are soundly established before you proceed.

During its construction the drawing was snatched from me and photographed seven times, each exposure marking a distinct stage in its completion.

First of all, study the finished sketch carefully, then glance at each successive stage, and see if you can follow the way in which it has, quite literally, been built up.

Apart from the notes I have made against each drawing, I do not intend to include any explanatory matter at this stage.

STAGE II. Still within the boundary of the rectangle. some of the broad features of the tank are indicated

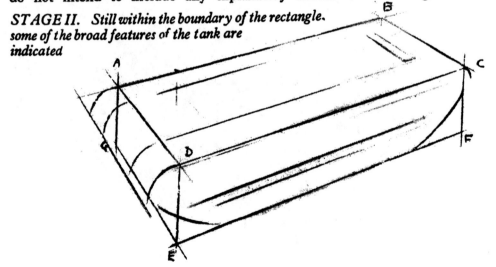

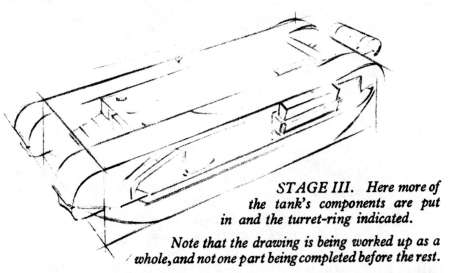

STAGE III. Here more of the tank's components are put in and the turret-ring indicated.

Note that the drawing is being worked up as a whole, and not one part being completed before the rest.

The lesson is designed purely as a means of showing, at a glance, the way in which a sketch of this sort may be compiled from a simple scaffolding of main lines. Later on we will tackle the job from a more detailed aspect, but before attempting this, try and "get your eye in" with the aid of these sketches and notes.

I should like to make it clear that I have been intentionally rigid with my treatment of this sketch, and I do not, by any manner of means, wish to lay this down as the ideal method of working your tank drawings up. I have adopted a rather rigid geometrical

STAGE IV. By the introduction of tone the drawing passes from its diagrammatic state to something more exciting.

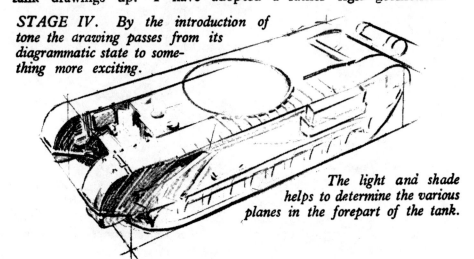

The light and shade helps to determine the various planes in the forepart of the tank.

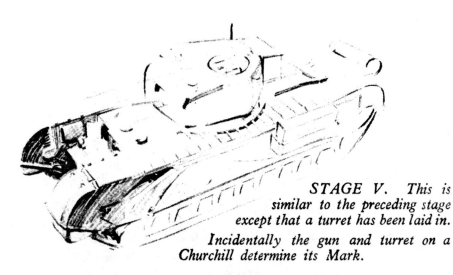

STAGE V. This is similar to the preceding stage except that a turret has been laid in.

Incidentally the gun and turret on a Churchill determine its Mark.

style as I feel that it is one that lends itself to this particular lesson.

It is not necessarily my method of laying in a tank drawing, and certainly need not be yours. Its mission is just "to get the wheels turning"; to give a sound and straightforward notion of how to get to work. A grounding.

Later on, as your experience develops, you'll very soon find yourself developing a style of your own, and no longer requiring the support of any specific guide laid down by somebody else.

STAGE VI. Work continues on the turret, bringing it to the same stage of finish as the forepart.

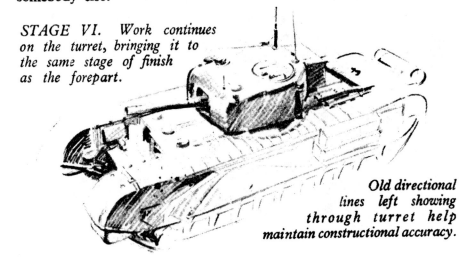

Old directional lines left showing through turret help maintain constructional accuracy.

14

CONSTRUCTION AND PERSPECTIVE

Now let us get straight on with the next lesson.

The type of Tank I have chosen, although now completely obsolete as one of Britain's fighting vehicles (heaven be praised!) makes an excellent model for the beginner owing to its angular construction and simple block masses.

The first thing then is to decide on the angle from which we want to

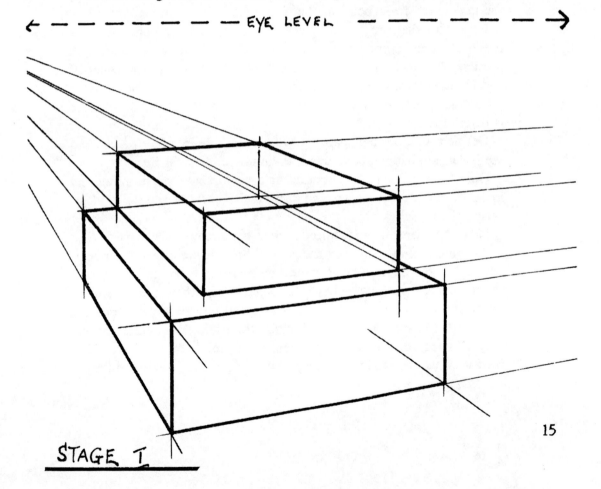

← – – – – – – – EYE LEVEL – – – – – – →

STAGE I

15

draw our tank. For the sake of argument I have chosen a three quarter front view, taken from an elevated position as if the artist were looking down on the tank from raised ground or from a first storey window.

You know the rule about parallel lines. *Actually* they never meet, but *visually*, when they are extended into the distance, they will eventually meet at infinity, and at the point where they converge will be found the eye level of the person viewing your drawing. (See **Stage I, page 15**).

In this sketch I have reduced the construction to its simplest form, that of two boxes. The lower representing the hull and track assembly, the upper, the main body of the tank.

I fear this diagram rather flavours of the geometry book (never a friend of mine !), but my object is to make it as clear and simple as possible. Actually one need not rule lines and the sketches on pages 10 and 11 show some alternative methods of "laying in your tank". Note the various points of view in these, and how the eye level in each case is determined.

Get hold of a piece of paper now, and scribble in a few roughs and see if you are happy about this question of directional lines.

Our skeleton framework soundly laid we can now push on and get in some of the other planes and the circular parts of the tank. (See **Stage II, opposite**).

Note the turret with its queer shaped hatch-cover, the driver's visor and engine cooling vent, and the general lines of the caterpillar tracks. Also notice the sloping sheets of steel in the front, beneath the foremost of which the driver sits—they're interesting and they present several queer angles that we must tackle. You will notice, if you study the sketch, that in spite of the varied angles these additional parts present, they all conform to the normal rules of simple perspective. For instance if we were to extend the parallels of plate A (see dotted lines !)

upwards, they would eventually meet. Which means that in your drawing the bottom of the steel sheet, being nearer your eye, must appear a fraction broader than the top (measure it for yourself). Try and apply this rule automatically to each plane on the tank.

Now, a hint or two on ellipses and the perspective of wheels.

When you sketch in the turret for example, don't be content to stop your pencil where the curved line disappears from view, but follow through behind and complete the ellipse. (See Fig. I, overleaf). Unwanted lines can always be rubbed out later on, and you'll find that you will get a much more convincing circular appearance than if you stop abruptly at the vertical edges.

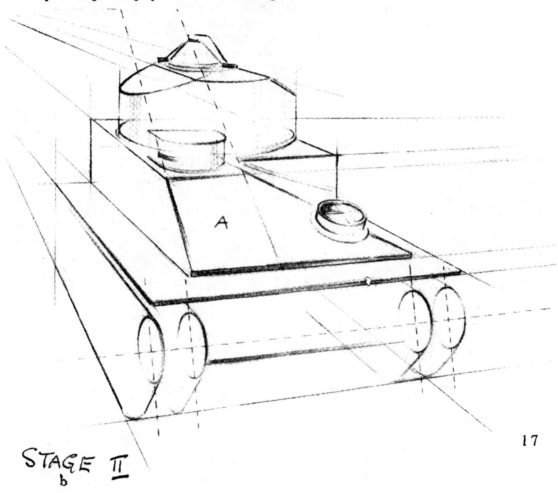

A

STAGE II
b

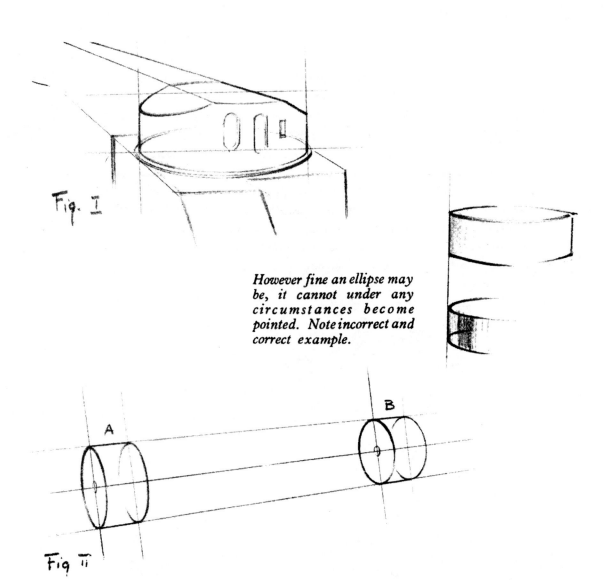

Fig. I

However fine an ellipse may be, it cannot under any circumstances become pointed. Note incorrect and correct example.

A

B

Fig II

In Fig. II., I have attempted to evolve a simple method of showing you how the perspective of the two front sprocket wheels of your tank must differ.

The wheel (A) nearest you is bound to look " thinner," or more in perspective than (B) which is further away. And for the same reason,

the face of the caterpillar on sprocket (A) will have greater width than that on sprocket (B).

Take a look at the wheels on any car or lorry and I think you will see what I'm driving at.

Before we leave the subject, study Fig. III carefully. You will observe that if the wheel is directly in front of your line of vision you see its full width but none of its side. Again as your eye travels along this line of wheels (all set on a common axle) you begin to see more and more of the side, and less and less of the width of each wheel.

Practise drawing a few of these details for yourself and see if you thoroughly understand them.

We can go on now to Stage III (see next page) and begin to get some tone, or light and shade into the job. The first thing here is to decide from which direction light is coming and to keep that lighting consistent throughout the sketch. In this instance we will assume that the sun is shining, and is fairly high upon the left of the picture and slightly behind the tank.

Now without becoming too deeply involved in the sinister subject of refractions and reflections of light, it is fairly

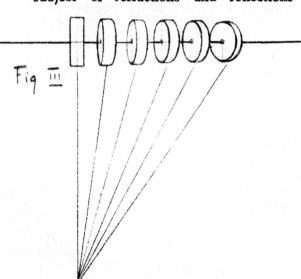

Fig III

safe for our purpose to assume that the plan which faces the sun's rays most squarely will be the one to reflect the most light and will therefore become the lightest plane in your drawing.

Very roughly speaking a, b, c, d (Fig. I,

19

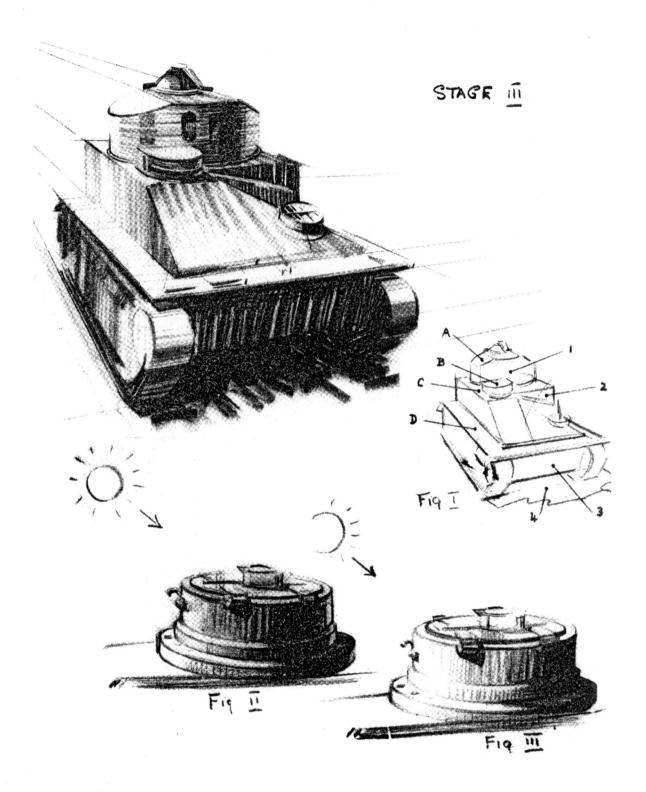

STAGE III

A
B
C
D
1
2
3
4

Fig I

Fig II

Fig III

opposite) are the planes that will catch the most light and 1, 2, 3, 4 are those, which being farthest from the sun's rays will receive the least light

Now look at Fig. II and III, opposite. I have drawn two sketches of the same cupola or commander's hatch. The light and shade on Fig. II is correct. That on Fig. III is incorrect.

With the light coming from the direction agreed upon one might be led to believe that the darkest part of the hatch would be on the extreme right hand side. This is not so—the darkest portion would be that immediately furthest from the source of light and although the right hand side does not come into direct contact with the sun's rays a certain amount of light becomes reflected into its surface thus relieving the intense shadow.

This reflected light may come from a number of sources. The sky, the ground, buildings or even trees and hedges, objects, which themselves are in direct sunlight.

Perhaps the next diagram will make matters clear (Fig. IV overleaf). But if you should still be in doubt, the best scheme is to go into the kitchen and bag a saucepan and stand it on the table. Arrange it so that the position of the light is similar to that chosen for our sketch. Now note carefully which position of the metal receives the most light and exactly where the heaviest dark lies. This experiment is well worth trying. You'll learn a lot from it, and it will help you enormously in dealing with light and shade later on.

I have included a close-up in Fig. V to show you how to make your caterpillar tracks really look as if they are wrapped round a circular sprocket. You will note in Fig. VI that the track plates progress round the wheel in a series of " jerks " or angles, and for the same reason that I explained earlier concerning the perspective of wheels, the tread that faces your eye most squarely will appear the widest, the

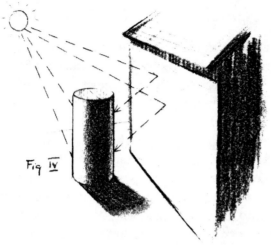

CONSTRUCTION
AND
PERSPECTIVE

Fig IV

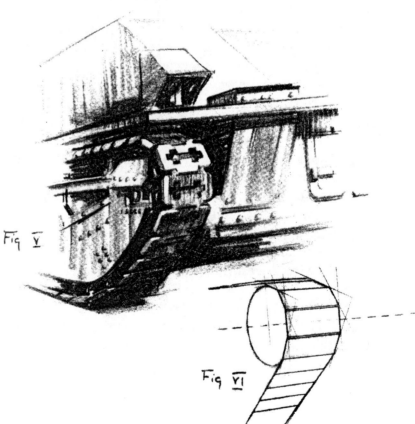

Fig V

Fig VI

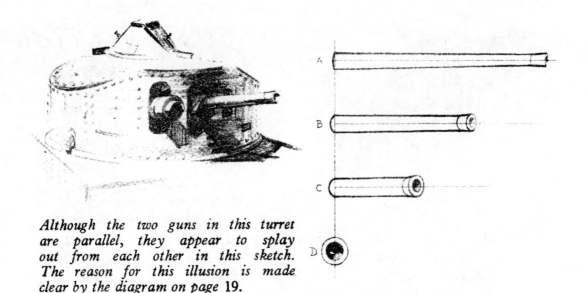

Although the two guns in this turret are parallel, they appear to splay out from each other in this sketch. The reason for this illusion is made clear by the diagram on page 19.

others both above and below will tend to become narrower as they recede from you. Here also light and shade play an important part in making the track plates turn correctly. One plate will catch more light than all the others and as the track recedes beneath the tank they will become darker in tone. (Figs. V and VI opposite).

Now let's move along to a more exciting stage, and start getting in detail, guns, grills, headlamp protectors, handrails, the delicate wireless aerial, hawsers and rivets, etc. There are all manner of bits and pieces to go in and they all help enormously to make a sketch. Before the guns are put in, take a look at the two sketches I have made of this cruiser's turret. Note what happens when the turret is revolved towards you. The long three pounder looks slim in profile, but as it swings to the right it tends to become foreshortened. The tapering of the barrel gets less accentuated and the muzzle ellipse grows in fullness. (See the four stages A, B, C, D).

Avoid the mistake of

A side view of the same turret. Note the driver's visor on the extreme left, and letter-box like slit in turret through which the co-axially mounted three-pounder and machine gun are sighted.

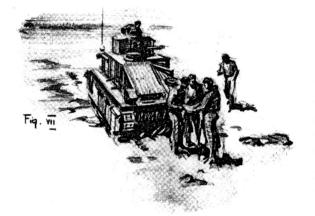

Fig. VII

over-elaboration. Details are fascinating to draw, but they can easily usurp too much attention and interfere with the sketch as a whole. Don't be too painstaking in putting in every rivet. Leave something to the imagination and try and develop the art of suggestion. It is much more telling and far less boring to look at.

We are now nearing the final stages of the drawing. (Stage IV). But at the moment our tank is suspended in mid-air, high and dry ! So we must get going with some sort of background.

As the position of the sun indicates, a fair depth of shadow will lend useful weight to the foreground and if treated loosely becomes valuable in suggesting rough broken ground.

Figures, trees, additional vehicles, buildings ; all these are useful components in building up an environment and for establishing comparisons. For instance, although your drawing may be big and on a large sheet of paper, unless you have other objects in the picture the observer will have no means of gauging the actual size of your tank. Again, human beings, trees or any type of vegetation, apart from establishing a comparison in size, are also valuable in accentuating differences of texture. The loose folds of a battle dress, for instance, or the bark of trees and delicate tracery of leaves, all tend to pronounce the smooth angular construction of the man-made fighting machine. (See Fig. VII).

Be careful not to make the background too important. Remember it is a drawing of a tank you've set out to do and not a landscape. If you should wish to put in other tanks in the distance, remember that similar patches of dark and shadow will look lighter in the more distant vehicle. The further away an object the lighter in tone its shadows tend to become.

AND PERSPECTIVE

OBSERVE THE UNUSUAL POSITION
OF THE WIRELESS MAST

STAGE IV

DESPAIR!

Before going further, a word about your own feelings.

If by now you have attempted a few drawings on the strength of what I have tried to teach you, unless you are a very exceptional student indeed, a feeling of utter hopelessness and despair will probably have got you firmly by the throat! Your sketch started well, but slowly and steadily it has grown more rotten with each stroke of the pencil. In short it has become a simply shocking mess, and apart from handing it to the salvage man you have no idea what to do next. Each stroke you make merely seems to add to the general ghastliness, and you are convinced your short career as a tank artist is here and now at an end! You rip up sheet after sheet. You curse me and your foot itches to kick the cat who sits complacently by the fire, indifferent to tanks and your sufferings alike.

But what you are going through, we have all had to go through. It's a beastly stage and you have my sincere sympathy, but its got to be faced. Don't let it discourage you. Don't tear up your sketches, however bad they may seem. Stick it out and carry them through as far as you possible can. There will be plenty of disheartening moments but believe me, they are nothing to the feeling of elation that comes when you know with certainty that you have made progress and your work is improving.

A good plan is to keep all your early work. It's interesting and encouraging to look back now and then and see how you have come on.

The tank artist's nightmare!

THE BEGINNER'S POINT OF VIEW

This is a wooden model of a P.Z.K.W.III German medium tank. It is roughly 15 inches long, 8 broad and 6½ high and is used for instructional purposes.

My reason for reproducing a photograph of it here is because it makes an admirable model for a beginner to sketch.

In this chapter are three unaltered pencil sketches made from this tank by three different men, all of whom show a keenness for drawing but possess a limited knowledge.

By using these examples of actual beginners' work, I want to try and give a helpful and constructive criticism of what I consider to be outstanding faults in each case.

(1)—Perspective and proportion.

If you refer for a moment to the diagrammatic sketches on pages 15 and 32, you will see how by failing to decide upon a given vanishing point this man has fallen down badly and produced a drawing that is constructionally unsound.

Again his knowledge of ellipse perspective is sadly lacking. If anything, the near front sprocket is fuller than the far one, instead of being the other way about. Have another glance at pages 18 and 19 and refresh your memory on this important point.

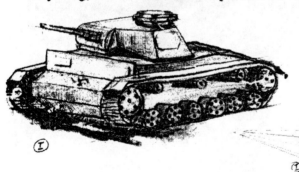

Also note how the direction of line on the treadplates differs on each track through lack of correctly drawn perspective lines.

Apart from this, there are definite shortcomings in proportion. The tank is too squat and broad for this point of view. Compare it with the photo. The use of tone also is indecisive and monotonous throughout the drawing.

(2)—This threequarter back view shows a distinct improvement on the first example. Although the perspective is a bit erratic and far from perfect, the general construction seems moderately well understood. The use of tone however, is inconsistent and he has missed splendid opportunities of suggesting planes by tone treatment.

Another inconsistency is his behaviour with ellipses. The hatch cover, for instance, is not at all bad, and one or two of the bogies appear to be fairly sound. But what has gone wrong with the gun barrel? It is surprising that a man who can draw ellipses moderately well in some parts of a drawing should make such ignorant mistakes in others. Although the drawing of the muzzle suggests roundness of a barrel

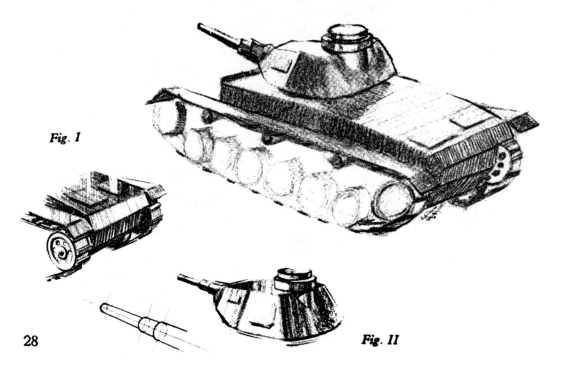

Fig. I

Fig. II

28

turned slightly away from the onlooker, the two greater thicknesses of the gun suggest a clean side view. (Fig. II).

Again, at the rear of the tank there are three distinct angles. The student has been at great pains to shade each, quite correctly, in the direction in which it faces. But in all three planes the tone is of equal weight and thereby the effect is completely robbed of success. Remember what I told you about light and shade. (See page 19.) These tones must vary in intensity in relation to the source of light (Fig. I). Again, in the turret, there was a glorious opportunity of effecting decisive drawing in the angular construction of the armour. This has been missed, by the indecisive " shading " that is prevalent throughout the drawing.

(3)—The author of the drawing overleaf, in spite of encountering plenty of difficulties, has made matters worse for himself in his selection of viewpoint. This elevated position with the gun turret out of alignment is one of the most difficult he could possibly have chosen. His rendering shows conscientiousness, and although the job has proved too much for him at this early stage it is instructive in bringing before our notice one very important lesson.

Observe the large expanse of top plane visible from this angle. Now the more you see of these top or horizontal planes, the correspondingly less you will see of the vertical ones. It is the same old story of the perspective of wheels I told you about on page 17. He has failed to show this. The caterpillar tracks, sprockets and bogies of this tank are not nearly foreshortened enough and, as well as suggesting a lower eye level view, they are drawn in a different plane from the rest giving the tank a twisted appearance. Note particularly the nearside leading sprocket. This is the worst offender. But are you sure you understand just why it is wrong? Let me try and make matters clear.

As the tank is approaching from a three quarter front direction, *none of the wheels under any circumstances can be fully round*. They must to some extent be in perspective. Again, if owing to the elevation the horizontal lines of the tank appear to slant, then the axles of the ellipses *must* slant too *at exactly the same angle*. Study these diagrams carefully and

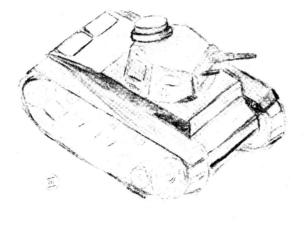

make quite certain that you understand them.

Fig. I shows an elevated view, but in spite of the wheels being nicely drawn in perspective, the effect is absurd. Why? Because the axles of the ellipses are out of perspective with the rest of the tank. Now glance down at Fig. II. You will observe that the perspective is the same, but here the axles of the wheels are *parallel* with all the other horizontal lines, giving the whole a soundly constructed appearance.

I don't intend to criticise this drawing for any of its other shortcomings, but before leaving the subject, one last word. Remember that from whatever angle you draw your wheel or turret or gun barrel, the axis of its ellipse must *always* be at right angles to its axle. Master this and you've made a big stride.

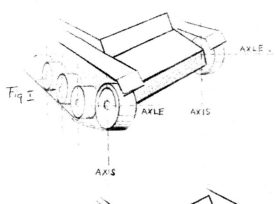

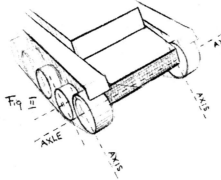

STUDY
OF
DETAIL

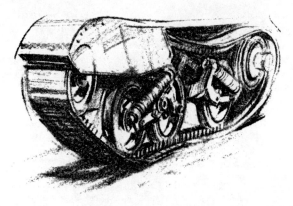

When you feel confident of "laying in" your tank pictures soundly, try sketching component parts, particularly those at which you feel yourself to be weak.

Spokeless wheels, a whip in the track belt and indecisiveness in the drawing of track plates all lend a suggestion of speed to a tank.

There's a lesson to be learnt in the first sketch on this page— the mud flaps that overhang the forward sprocket of this Bren Carrier. When sketching a detail of this sort indicate, quite lightly, the *whole* wheel. By drawing the concealed half as well, you will obtain a much truer feeling of roundness than by merely drawing the portion that is visible to the eye. Also note how an effect of speed can be produced by a certain treatment of wheels and track.

On the following pages you will find studies of a number of important details.

UNUSUAL DIAMOND SHAPED
TURRET OF THE MARK Ⅴ
CRUISER "COVENANTER"
 NOTE THE CENTRAL
POSITION OF THE PERISCOPE AND
THE PLACING OF THE WIRELESS
 MAST.

31

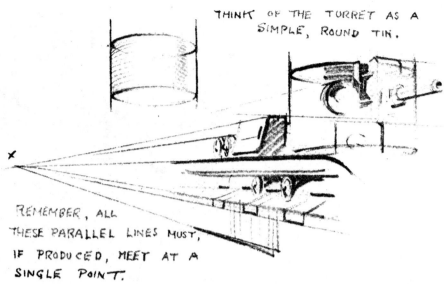

THINK OF THE TURRET AS A
SIMPLE, ROUND TIN.

REMEMBER, ALL
THESE PARALLEL LINES MUST,
IF PRODUCED, MEET AT A
SINGLE POINT.

This T28 Russian Medium was used extensively in the storming of the Mannerheim Line.

NOTE HOW SPARE
BOGIES ARE CARRIED
↓

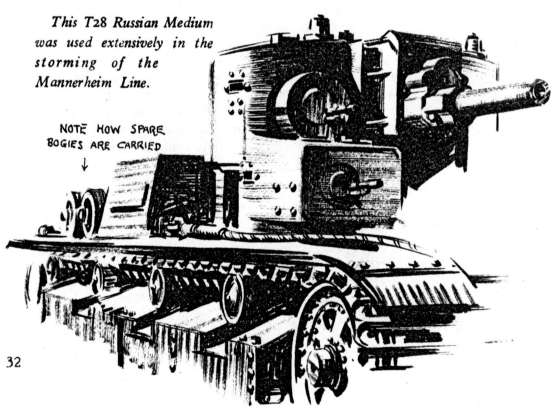

32

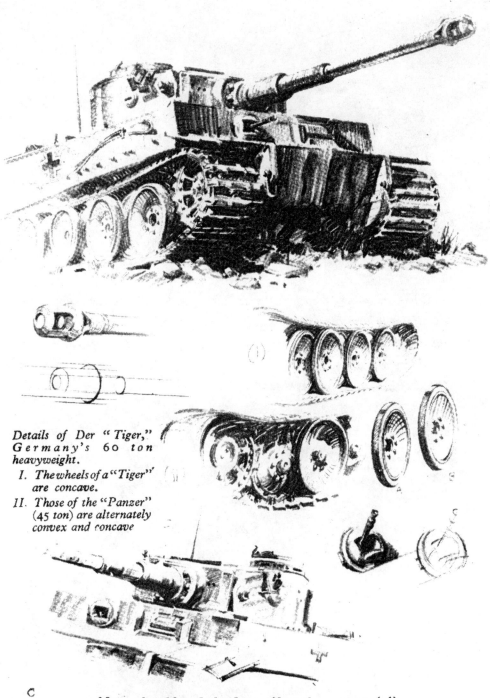

Details of Der "Tiger,"
Germany's 60 ton
heavyweight.

I. The wheels of a "Tiger"
 are concave.

II. Those of the "Panzer"
 (45 ton) are alternately
 convex and concave

Note the Muzzle-brake. Also the correct (A)
and incorrect (B) way to suggest a concave wheel.

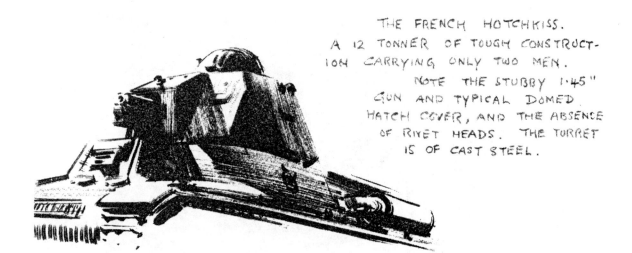

THE FRENCH HOTCHKISS.
A 12 TONNER OF TOUGH CONSTRUCT-
ION CARRYING ONLY TWO MEN.
NOTE THE STUBBY 1·45"
GUN AND TYPICAL DOMED
HATCH COVER, AND THE ABSENCE
OF RIVET HEADS. THE TURRET
IS OF CAST STEEL.

*When tackling details of this sort, make absolutely sure your
'scaffolding' or constructional lines are soundly laid in. Notice in
all these turret details what an important part tone plays in the
moulding of shapes, and how it can suggest the roundness of a curve or
the decisive angle between planes.*

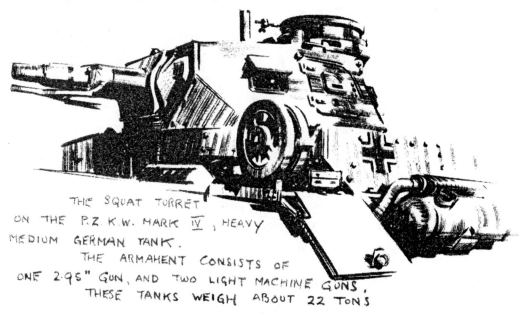

THE SQUAT TURRET
ON THE P.Z.K.W. MARK IV, HEAVY
MEDIUM GERMAN TANK.
THE ARMAMENT CONSISTS OF
ONE 2·95" GUN, AND TWO LIGHT MACHINE GUNS,
THESE TANKS WEIGH ABOUT 22 TONS

TWO INTERESTING OPPOSITES

(i) A STUDY IN STRAIGHT LINES.
(BRITISH CRUISER, CENTAUR)

(ii) A STUDY IN CURVES.
(AMERICAN SHERMAN.)

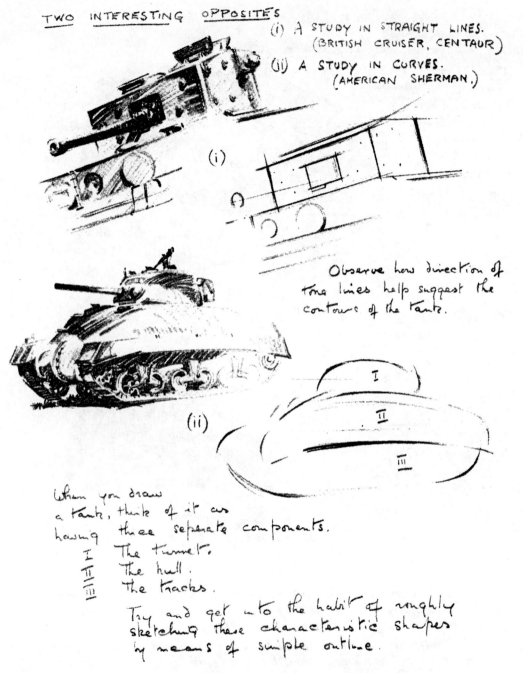

(i)

Observe how direction of
tone lines help suggest the
contours of the tanks.

(ii)

When you draw
a tank, think of it as
having three separate components.

I The turret.
II The hull.
III The tracks.

Try and get into the habit of roughly
sketching these characteristic shapes
by means of simple outline.

35

TWO ASPECTS OF THE SAME TANK; AGAIN, CURVES AND STRAIGHTS.

From a ¾ side view, this T.34. Russian cruiser presents a pleasantly rounded contour.

But seen from a different point of view the same model appears almost triangular!

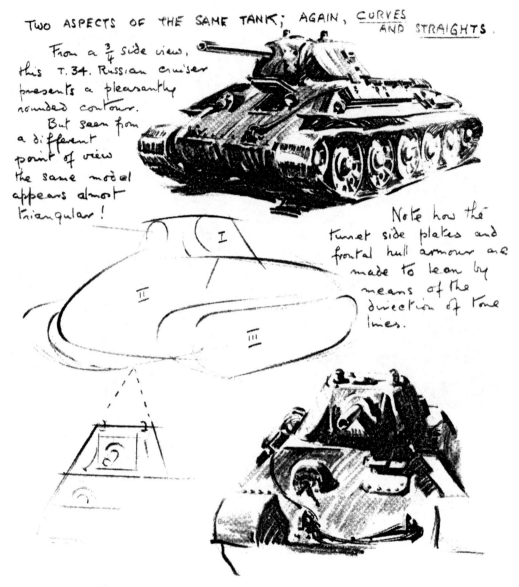

Note how the turret side plates and frontal hull armour are made to lean by means of the direction of tone lines.

The T34 cruiser, by the way has been one of Russia's most famous and successful tanks. It weighs around 26 tons, carries a 76 mm gun and one machine gun, and has a speed of about 34 m.p.h.

It is interesting to note that this tank was developed originally from the American Christie design and has progressed along similar lines to the British Crusader (see opposite page).

FASHIONS IN WHEELS AND SKIRTINGS

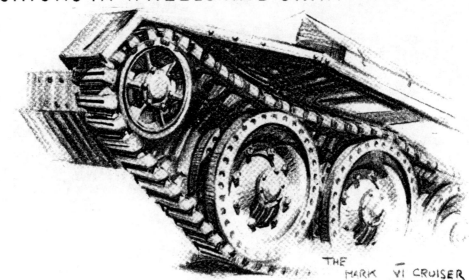

THE MARK VI CRUISER "CRUSADER" HAS FIVE EVENLY SPACED WHEELS EACH SIDE. THE "COVENANTER" HAS FOUR, UNEVENLY SPACED. THE "CRUSADER" WEIGHS 18 TONS, 2 TONS HEAVIER THAN HER SMALLER SISTER "COVENANTER".

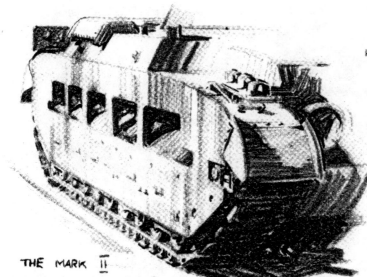

THE MARK II "MATILDA" HAS HEAVILY ARMOURED SKIRTING AND SMALL BOGIES. THERE ARE ELEVEN WHEELS EITHER SIDE. SHE IS DRIVEN BY 2 ONE HUNDRED H.P. DIESEL ENGINES.

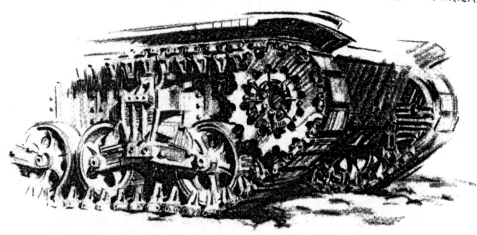

THE TYPE OF BOGIE
FAVOURED IN AMERICA.

When sketching the close-up of a driving sprocket, (I can promise you you'll find this American pattern by far the hardest to tackle: it makes me think of a lace table mat, and is just about as intricate to draw!) remember that the teeth must come between the coupled track pins in just the same way that a chain-wheel fits into the links of a cycle chain.

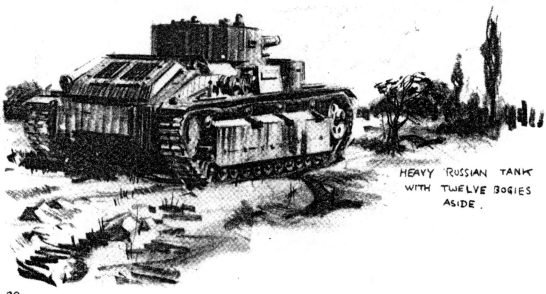

HEAVY RUSSIAN TANK
WITH TWELVE BOGIES
ASIDE.

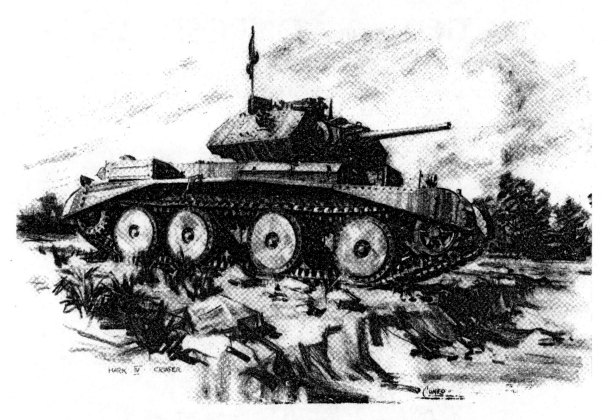

MARK IV CRUISER

Study carefully and see how the direction of tone helps suggest the planes. This is particularly apparent in the *Mark IV* cruiser. (This tank, by the way, although now used almost exclusively for training purposes was the forerunner of our fast *Covenanter* and *Crusader* machines. The turret and parts of the hull have been remodelled but the wheel arrangement is identical to that of the *Covenanter Mark V* Cruiser).

See also how the various gun barrels look in their different perspectives. There are several examples.

Apart from drawing them, try and absorb the characteristic details of the various models of tank both British and foreign with a view to identification. Your ability to recognise a particular tank might prove to be of vital importance to your country some day. Increase your powers of observation in every way you can and learn to " spot them on the road " with confidence and decision.

ACTION AND COMPOSITION

To get our tank drawings to look vigorous and full of movement we must compose the whole picture with this idea in view. But first, let's try and find out exactly what it is that makes an object drawn on paper appear to move at a rapid pace.

We've all in our early days, drawn pictures of trains, and what a godsend the smoke was and the clouds of steam that we had belching from the cylinders. Something like this—

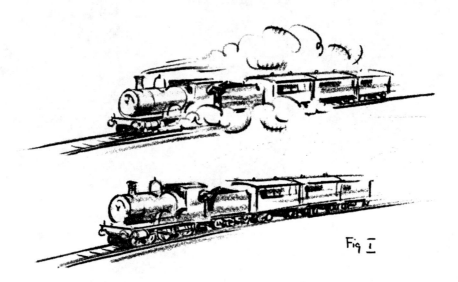

Fig I

I know it was a glorious chance to get out of drawing rows of frightful wheels but, for all that, we had the right idea. Strip the child's puff-puff of its smoke and we have completely robbed the train of movement. It looks motionless and forlorn, and lifeless in the extreme. But why should smoke coming from a funnel suggest

40

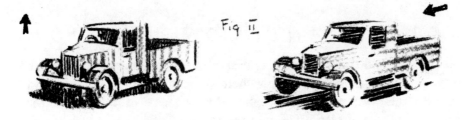

Fig II

movement. Is it because we know a moving locomotive exhales smoke in its progress? No, that is not the answer. The secret lies in the *direction* of the smoke clouds. They do not mount straight up into the air, but flow in sympathy with, and roughly following the line of, engine and carriages. And by this means an illusion of movement is produced.

Here's another example (Fig. II). By using tone lines in sympathy with, and not antagonistic to, the general line of direction, this car is made to appear to bound along at positively breakneck speed.

Again, if in a sketch we put in a number of objects antagonistic in direction to the progress of a moving tank, these are bound to produce a slowing down effect on the action of the drawing. Study these two scribbles and I think you'll see what I'm driving at. (Fig. III).

Rigid vertical lines are all retarding influences on this type of action

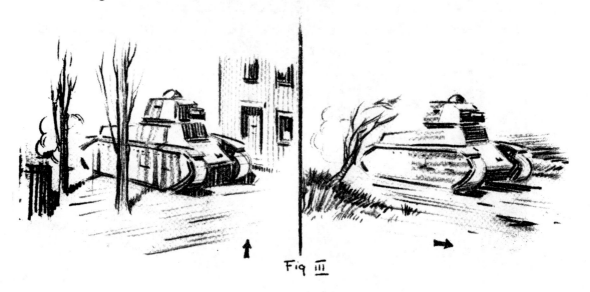

Fig III

picture. Avoid them as much as possible. If they must have a place
in your composition, don't allow them to become too important, and
counter their influence by keeping the majority of tone lines (or
shading) in the direction of movement.

In the picture of the Libyan desert on the opposite page, action has to
had to be the keynote.

You'll probably pounce on me and say, " Look at his palm trees,
they are vertical ! And so are those barbed wire stakes ". Let me
try and explain my motives here.

The trees were a necessary evil. Useful from the point of view of
environment and local colour, but of little assistance to the action of
the armoured vehicles. You see, this picture relies for its vigour on
the general lines of composition, and on the use of shadow.

The following armoured car, the shattered Italian machine gun post,
the crazy stakes and broken wheel are all carefully placed to form a
sympathetic accompaniment to the main interest—the speeding bren

Armoured car Machine gun nest.
Other Bren-carriers. Posts & cart wheel.
Leaves, & tree shadows. Shadow of the Bren-carrier itself
 and last but not least, direction of dust cloud.

All these objects help produce a smoothe flowing
action to the drawing

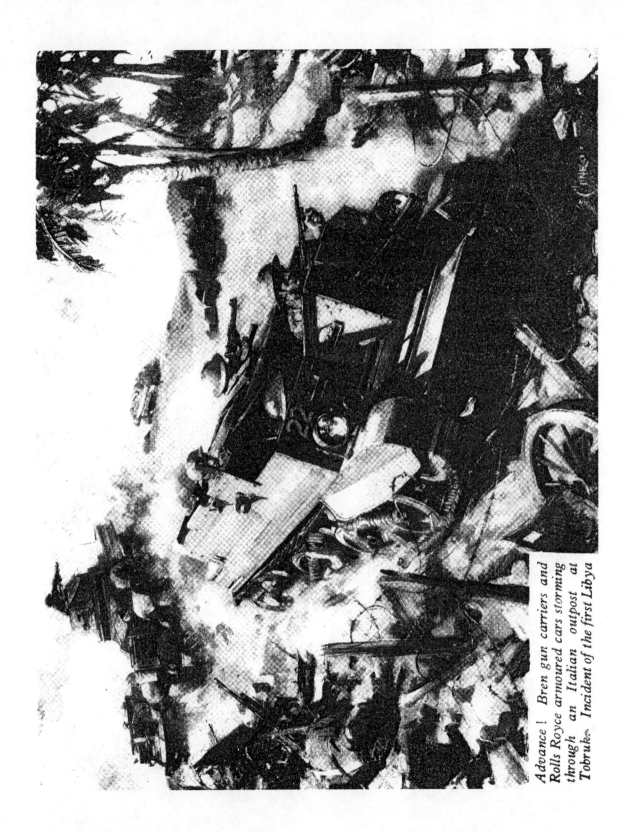

Advance ! Bren gun carriers and Rolls Royce armoured cars storming through an Italian outpost at Tobruk. Incident of the first Libya

ACTION AND COMPOSITION

carrier. Study these roughs I have made and compare them with the finished painting.

In this next example I have gone out for an entirely different effect. An impression of slow but ruthless progress was the primary consideration and not speed.

This oil half-tone drawing, done in the early stages of the war, depicts heavy French tanks in action between the Maginot and Siegfried lines. I chose to incorporate it as I consider it a good example of the use of exaggerated perspective. The steep upward tilt of the tank suggests menacing weight, whilst the splintering tree lends an atmosphere of ruthless and uncheckable progress to the machine.

Again the firing gun is useful with its suggestion of aggressive activity.

These directional lines and the weight of their tone suggest an overpowering and threatening atmosphere.

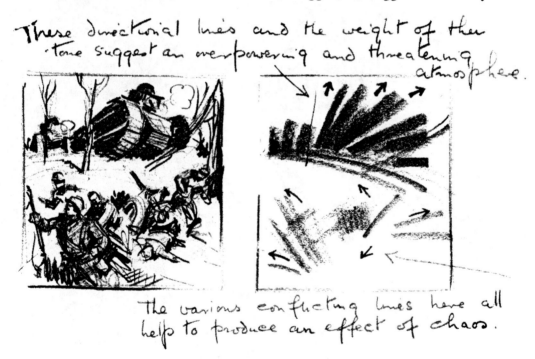

The various conflicting lines here all help to produce an effect of chaos.

44

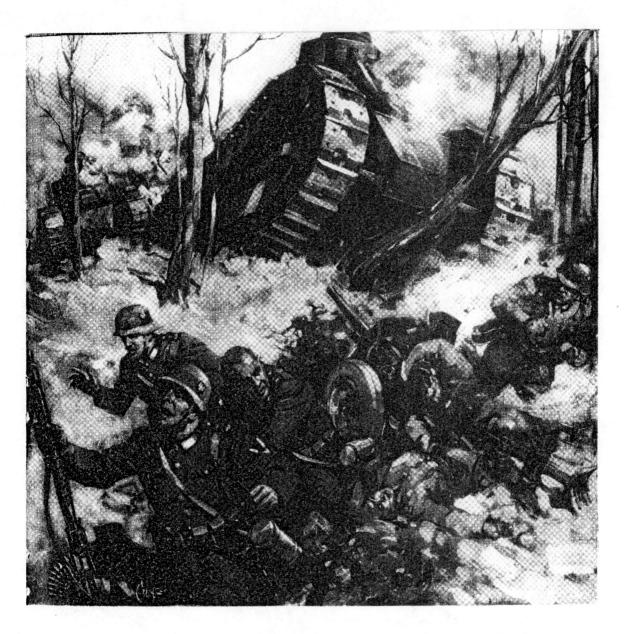

Early Days on the Western Front. A column of heavy French tanks advancing in front of the Maginot line routing a German patrol armed with automatic rifles and anti-tank guns. (Oil painting).

ACTION AND COMPOSITION

In spite of the irony of this particular subject, I like to feel that the fleeing Boche might be forgiven their obvious display of terror and confusion at the ponderous approach of such a monster.

Let us suppose you've made a careful study of some particular tank that interests you, and when finished you feel that a degree of action would add spice and remove the rather lifeless appearance of the drawing. Here is a compromise you can make.

Indicate a rough undulating countryside, and show deep impressions in the soil made by caterpillar tracks. Sketch in a cloud of oily exhaust smoke blowing out from the silencers and perhaps a loose stone or two, worked loose by the spinning outer track as the tank swings to port. This is quite sufficient to make your picture " live ", and avoids the embarrassment of having to introduce figures if your draughtsmanship is not up to it. Anyway this was exactly what I did in this portrait sketch of an immense veteran of 1933. In her youth, this tank was capable of speeds up to 45 m.p.h. Her armour, however, is comparatively thin and her weight only sixteen tons. As a point of interest, the main entrance to this steel castle is that squarish hole near the front of the skirting between the caterpillars. One crawls up this wood covered shute into the main turret. The smaller machine gun turrets can be reached, either from the main one, or by their individual hatch lids.

Take a look at the charcoal sketch on page 48 of a 28 ton *Matilda* undergoing repairs. This is an instance where vertical lines are definitely useful in putting over a certain effect. They tend to enhance the feeling of immobility which is exactly what is wanted in a drawing of this sort. The tank quietly resting there, whilst mechanics move to and fro about her, seems well posed to impress one with a sense of her terrific weight and latent power.

Here are one or two tips on the subject of composition that I think you will find useful.

Before starting a drawing get some scraps of paper and rough-in the general arrangement of your intended design. By doing this you will have a reliable chart of where everything is to be placed in the finished article.

For example. If you are attempting to build up a sketch of a *Matilda* moving along in open country, similar to my effort on page 49 (which was executed from a precarious perch on top of a concrete pillar), the placing of the tank on the paper is of the greatest importance. Look at three rough " comps " of the same drawing and let's see what is wrong with each of them.

No. I.—The composition itself is fairly sound. As a design, the

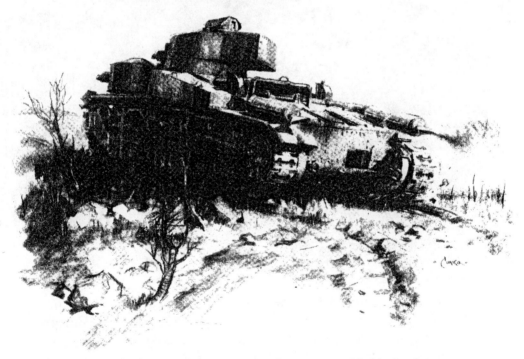

A Veteran of 1933. *She is now in the process of being broken up.*

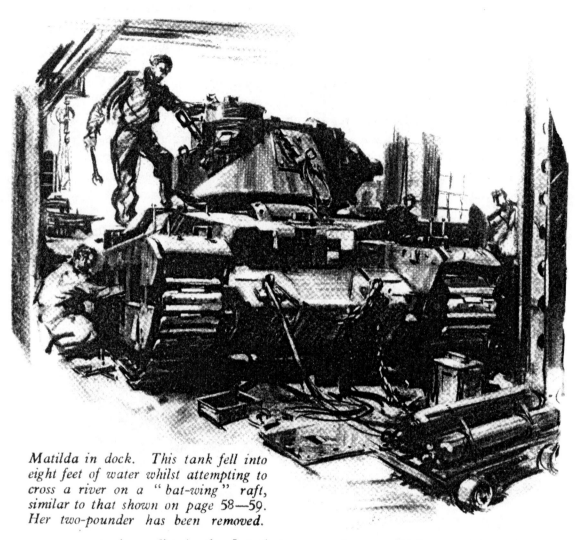

Matilda in dock. This tank fell into eight feet of water whilst attempting to cross a river on a "bat-wing" raft, similar to that shown on page 58—59. Her two-pounder has been removed.

weakness lies in the fact that too much strength has gone into the modelling of trees and trench. These, you will notice, are altogether too important and tend to dominate the interest at the expense of Waltzing Matilda herself. Avoid this tendency and always keep a background in its place, particularly in this type of study.

No. II.—The fault here is bad placing. The weight is too low and gives one the uncomfortable feeling that the tank is about to fall clean

A Mark II Infantry tank swings her guns. These Matilda's are armed with a two-pounder, Besa machine gun and a Bren for use against aircraft.

d

through the bottom of the picture ! Note also the displeasing effect of the gun. Its muzzle barely clears the edge of the paper. Always leave yourself plenty of margin in which you are able to expand the drawing, if necessary. Superfluous paper can always be cut away if it is not required, afterwards.

No. III.—This design is spoilt by a spotty and disjointed treatment. One is conscious that the artist has been at great pains to have something going on in each corner of his drawing. The eye is forced to dodge from place to place. There is no peace or concentration anywhere. All the spots, including the unfortunate tank, are of almost equal importance and weight.

In a good composition, everything should tend to lead the eye towards the centre of interest. Try and avoid conflicting lines that carry the eye away, or objects that supply a too important secondary interest.

Before we leave the subject of composition, a word on figures.

Whenever incorporating figures in your tank drawings, whether for purposes of indicating comparative proportions or as additional factors in battle scenes, don't place them any old how, or wherever a clear patch of paper presents itself. Get an old envelope back and make a rough composition, and decide clearly where you intend your figures should come before you start on the tank.

The drawing opposite was made on an R.E. demolition ground. This obsolete old cruiser has received the attention of various types of grenade, bombs, anti-tank mines and even torpedoes, and the results of their destruction are duly noted.

As in the case of the Matilda, I have laid in three roughs, all of which, to my mind, possess definite shortcomings from the point of view of figure composition.

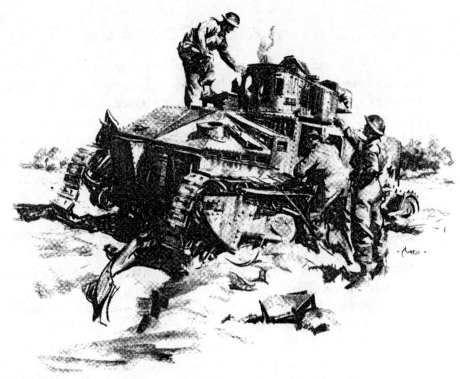

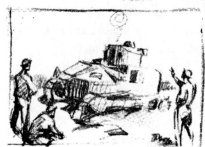

A martyr of the demolition ground. This obsolete cruiser is the same model as that on page 25.

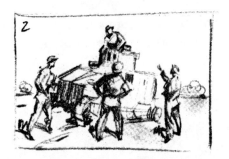

ACTION AND COMPOSITION

No. I.—In this case we cannot help being aware that the artist's primary interest has been with the tank, and although he has decided, possibly against his better judgment, to include figures, he has no intention of allowing them to become detrimental to its portraiture by obstructing any single portion of it. The way they are grouped, painstakingly and completely clear of the stricken machine, gives one the uneasy feeling that their presence is unnatural, and indeed we should feel a lot happier without them altogether.

No. II.—In this case it is again a matter of bad placing. The three men on the ground are all standing on the same plane and the spacing between them is unnecessarily accurate. Even the figure on the turret conforms with this rigidly symmetrical make-up. Although, here, the artist has not objected to his figures becoming a part of the drawing, he has defeated himself by producing a stilted unnatural picture.

No. III.—In this last one, let's assume that he has chosen a composition similar to mine, with one exception. The Sapper I have shown looking into the tank's interior, he has preferred to place more to the left and pointing up at a companion above. If you study this rough I think you will agree that the design produces an unfortunate effect. The man above gives the impression of standing on the other's head. It is a case, and a common one at that, of one figure seeming to grow out of another. Always watch carefully for this in your work.

There is no earthly harm in having one figure cutting into and partially obscuring another, but this illusion of acrobatics and feats of balance should be religiously avoided.

To sum up, draw your figures freely. Make them look as if they are doing a natural job of work, and arrange groups in such a way that they will assist and not be detrimental to your composition.

BATTLE SCENES, EYEWITNESS DRAWINGS & THE ILLUSTRATOR

The following pictures of tanks in action and in battle were all done to illustrate some actual event in this war. For drawings in this category several factors must be observed and taken into consideration, both by the artist and his public.

Firstly and from the artist's point of view, there is the all important factor—speed.

In modern warfare events change with such rapidity that unless the required illustration can be completed at very short notice, it may stand a grave chance of becoming out of date and valueless for publication, even within a matter of hours. Speed, therefore, decision in application and assurance in his ability to get a job in on time is vital to the war artist.

Other factors are ability to suggest movement, a sense of imagination and a sense of drama. The artist cannot be present at all the scenes he is called upon to illustrate. Therefore he must rely upon his own store of knowledge, his collection of reference books and photographs and any information he is able to glean from people who may have witnessed the incident. From these sources he must build up a vivid portrayal of any incident that he may be commissioned to illustrate.

There is yet another factor—perhaps the most important of them all from the public's point of view—*accuracy*. A drawing may be good, it may be vigorous and tell a dramatic story. But is it accurate? Can the technical details shown be relied upon? This point is a constant bogey to the war artist and it is on this point more than any other that he lays himself open to the severest criticism from the layman and the expert.

A man picks up a magazine in which there is an artist's impression of a fierce tank battle in the heat and dust of Libya. This gentleman has a knowledge of tanks, and being interested in them technically, his eye eagerly scans the various types shown in the illustration, not to digest any particular merit in the work but for the likelihood of finding out mistakes. Almost in triumph he calls a friend over and points the drawing out to him with a fine show of tolerant contempt. " This

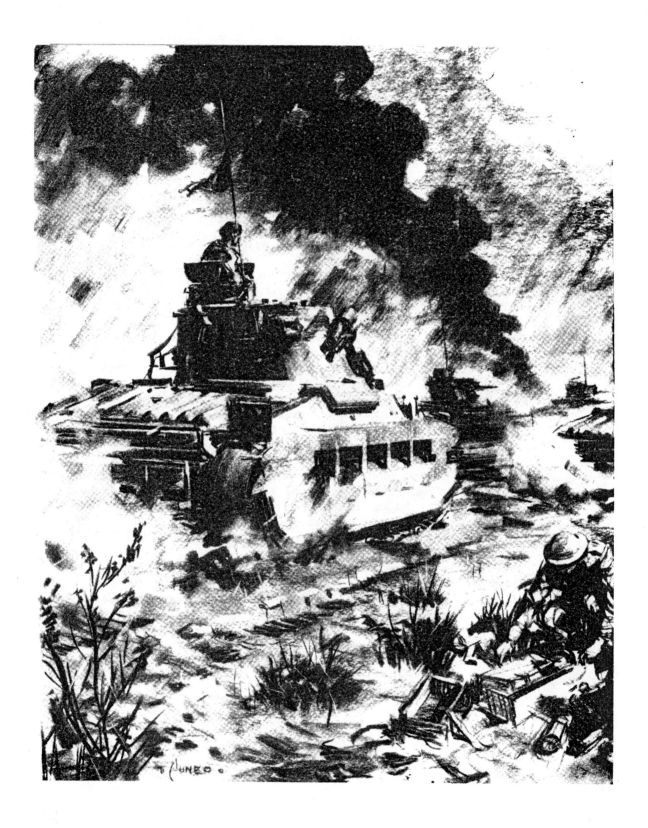

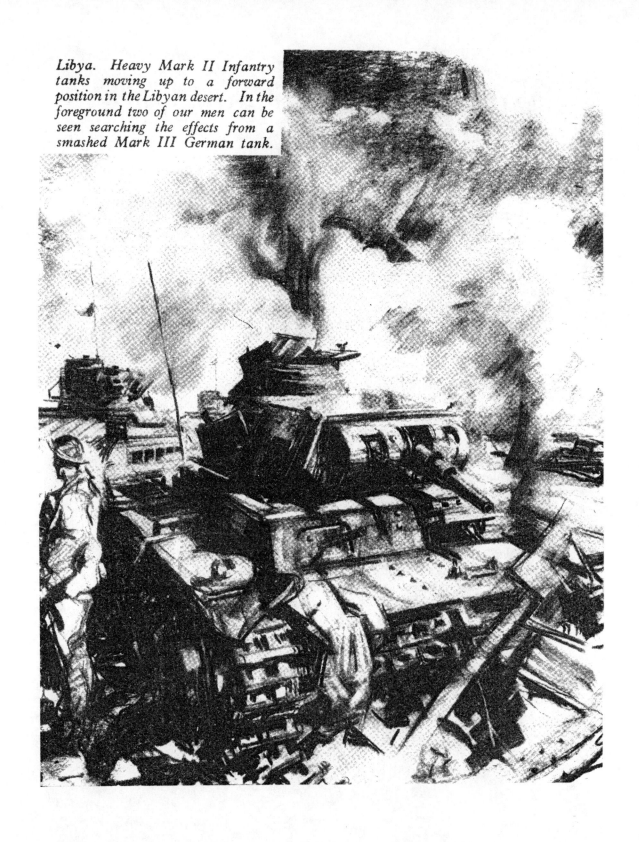

Libya. Heavy Mark II Infantry tanks moving up to a forward position in the Libyan desert. In the foreground two of our men can be seen searching the effects from a smashed Mark III German tank.

BATTLE SCENES, EYEWITNESS DRAWINGS AND THE ILLUSTRATOR

wretched fellow ought to be shot " he pronounces, " Who ever heard of a Boche Mark II with only three return rollers ? " (Actually the P.Z.K.W.II, like the Mark I and Mark IV has four return rollers, or jockey wheels).

Or " This blighter has stuck the aerial on the *body* of a Crusader ! " (British tanks carry aerials on the turret. The drawing on page 25 is a rare exception to this rule).

Or, " Can you beat this ! Here are a couple of Valentines in a scrap and the driver's window is shown *open* ! " (If the tanks were under fire, the small spy-hole or visor in the front would be closed and either the periscopes above would be used or else the thin slits in the visor itself).

Definite mistakes I grant you, but easy ones to make under certain circumstances.

I remember in the early part of the war being commissioned to paint a picture of the first Heinkel to crash on British soil. The illustration depicted the disabled machine flying low over a bus near the Scottish village of Humble. Now at that time we had comparatively few details of the Heinkel III and although I was supplied with photos of the wreck, much had to be left to my imagination. Believe me there were plenty of mistakes in *my* Heinkel ! But the point I wish to make is this. People seeing that drawing now could point out a score of stupidly obvious errors, as they certainly did, but at the time, the sketch was fairly safe from adverse criticism as the type of plane was then unfamiliar to us.

I don't by any means wish to convey the impression that I am making excuses for ignorance and incompetence in mine or other men's work, but next time you feel in a critical frame of mind try and remember what I have said. It is just possible the artist might be entitled to the benefit of the doubt.

Sketching inside factories can present an assortment of nightmares. Nothing ever keeps still. Nothing waits for the wretched artist ; not even the machines ! The only way to cope is to follow the activity about, making lightning notes and building up the required data piece by piece (see page 60). (One of a set of drawings recording Britain's Tank Production, and bought by the nation as an official War Record).

56

Fitting tracks to a Churchill IV. Charcoal drawing from sketches made on the spot in a British Tank Factory.

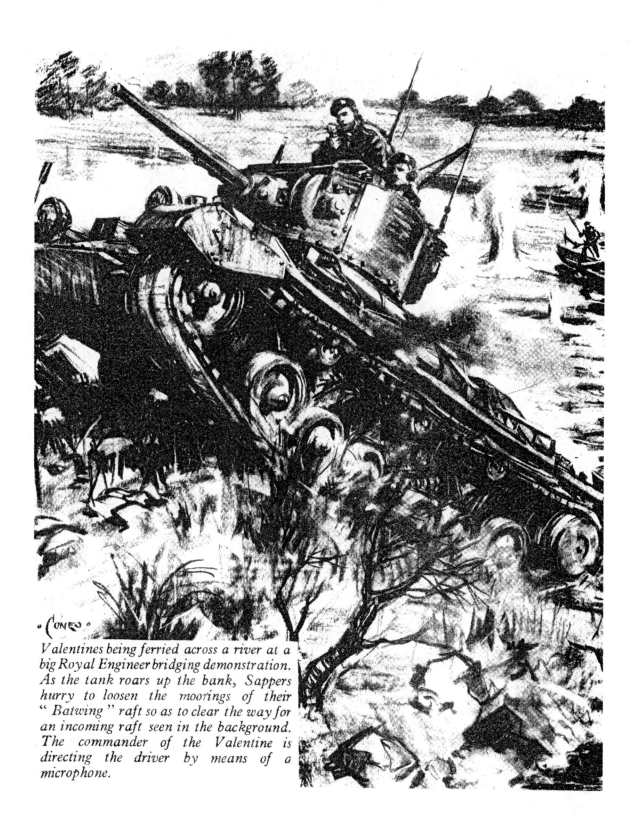

Valentines being ferried across a river at a big Royal Engineer bridging demonstration. As the tank roars up the bank, Sappers hurry to loosen the moorings of their "Batwing" raft so as to clear the way for an incoming raft seen in the background. The commander of the Valentine is directing the driver by means of a microphone.

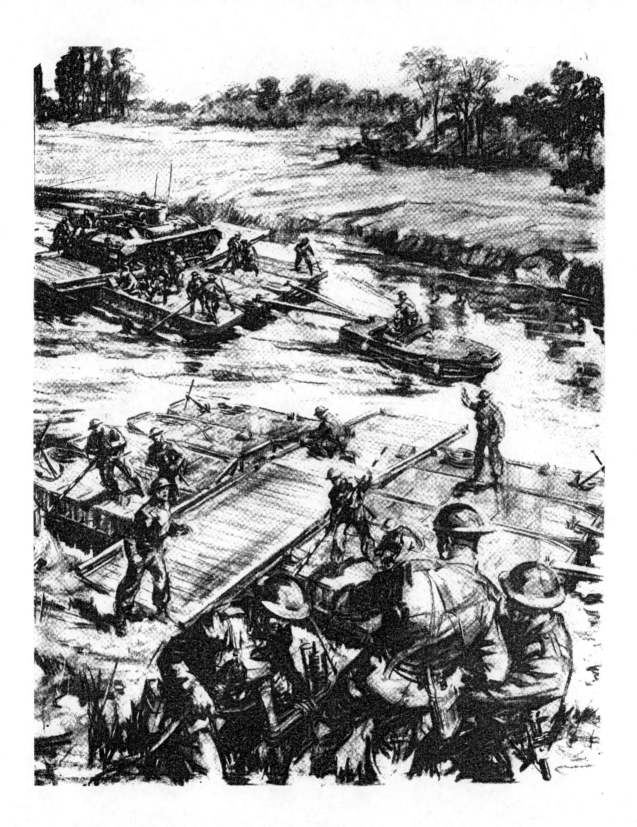

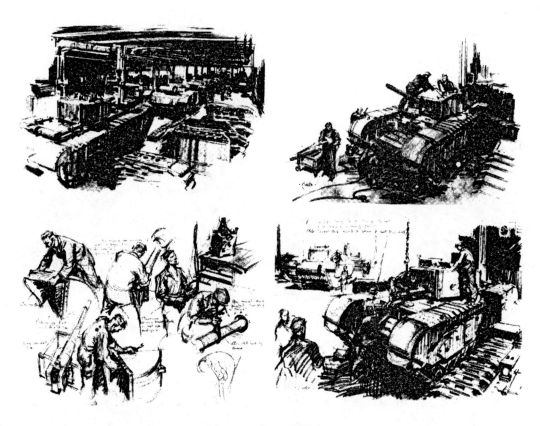

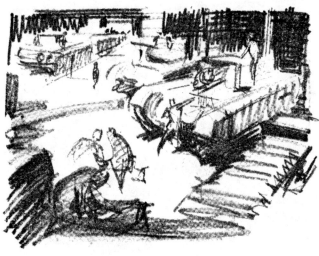

*From these four indi-
vidual sketches made on
the spot, and from this
rough composition note, the
charcoal drawing on the
opposite page was built up.*

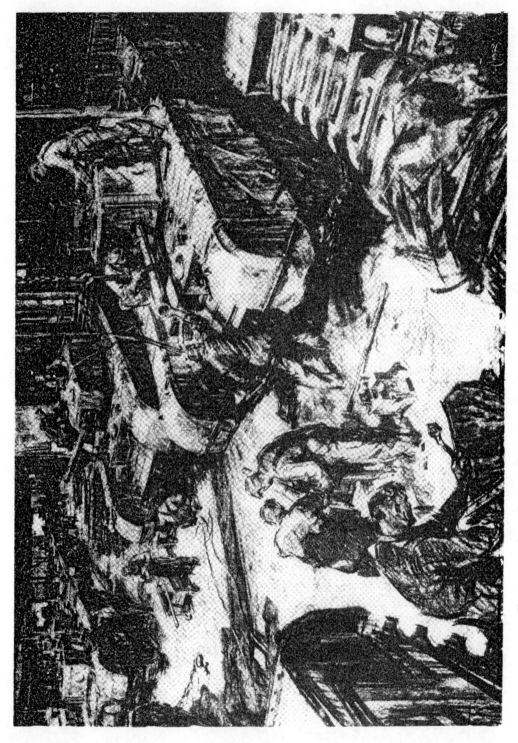

Fitting a short barrelled 6-pounder into a Mark III turret of a Churchill.

CHOICE OF MEDIUM

Before closing perhaps a word or two on the subject of mediums would be helpful.

There are any number of opinions on this wide subject, and you will get people who dogmatically put forward indisputable reasons as to why one particular medium should be adopted and be far superior to another. In my humble opinion any medium is a good medium, if you yourself are capable of producing the desired effect with it. You may choose oils, water colours, or pencil, or even soot or theatrical grease-paint for that matter, and if the finished effect is good and genuinely pleases you, then you have found your medium and can let people express whatever views they like on the subject.

I have drawn up a short list of mediums together with my opinions of their characteristics and advantages. Read them through. Try out some of the more convenient of them and then decide for yourself.

PENCIL. Excellent for all forms of sketching, including out-of-door work. Also good for making either quick notes or elaborately detailed drawings. Possibly the best and most easily handled medium for the beginner. There are various types to choose from. Lead, carbon, chalk, conte, litho, etc.

CHARCOAL. Very attractive and sympathetic to use. A quick spontaneous medium with grand opportunities for effects of light and shade. It is, however, somewhat awkward to handle, particularly out of doors, as it smudges easily and the bloom of the carbon gets blown off if there is much wind.

INDIAN INK. Excellent for quick and vivid effects. It also forms a good base for water colour or for tinting with crayons. Try using it with a small pointed sable brush instead of a nib. You'll find you get some nice effects with practice.

A fountain pen, by the way, can be an excellent medium for sketching. Experiment with yours and you will find you get pleasant soft effects by smudging in the ink with your finger and treating the work loosely.

CHALK AND CRAYON. These are useful and easy to handle, but it is difficult to get much subtlety of tone. Again with chalks, smudging is the chief drawback, and the greasy quality of crayons makes it unsatisfactory to superimpose pencil or ink over their surface.

WATER COLOUR. I think this is the best medium if you are keen to paint or to run flat washes of colour over your pencil or

ink drawings. The paraphernalia necessary is small, compact and easily carried in a pocket.

OILS. I'm afraid this medium is fraught with all sorts of difficulties to the beginner, and the equipment is cumbersome, heavy, and also expensive to buy. You will have to start thinking in terms of easels, palettes and wet canvasses and an almost frightening array of hogs-hair brushes, palette-knives and odd pieces of rag. No, I should never recommend any one to start from scratch in oils although I think perhaps it is my favourite medium and the one which I have used for the majority of my drawings since the beginning of the war.

In conclusion, I sincerely trust this book will prove to have been of some real assistance to those of you who are interested in modern engines of war and who are keen to develop the ability to portray them on paper. Good luck, and good sketching.

THE END

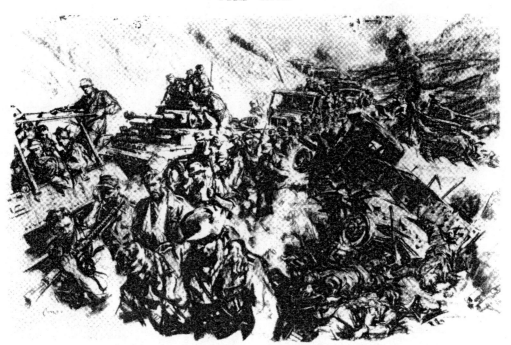

The rout of the Afrika Korps.

CPSIA information can be obtained at www.ICGtesting.com
Printed in the USA
BVOW06s0203210814

363585BV00032B/538/P